HATSUNE MIKU
初音ミク
Graphics 2
VOCALOID ART & COMIC

ENGLISH EDITION CREDITS

English Translation
JOCELYNE ALLEN

Copy Editing
ASH PAULSEN

Layout & Design Adaptation
MARSHALL DILLON

UDON STAFF

Chief of Operations
ERIK KO

Managing Editor
MATT MOYLAN

Project Manager
JIM ZUBKAVICH

Director of Marketing
CHRISTOPHER BUTCHER

Marketing Manager
STACY KING

Associate Editor
ASH PAULSEN

Copy Editing Assitance
MICHELLE LEE

Japanese Liaison
STEVEN CUMMINGS

JAPANESE EDITION CREDITS

コンプティーク編

●発行者
新名新

●編集
多田年礼（角川書店）
湯浅真彦（角川書店）
貞松佳太（角川書店）
竹之内大輔（レッカ社）
花倉渚（レッカ社）
伊東千晴（TINAMI）
中村清悟（TINAMI）

●執筆
堀野和宏
中村仁嗣

●制作
飯田均（角川書店）

●装丁・デザイン
中西知子

HATSUNE MIKU GRAPHICS VOCALOID ART&COMIC volume 2
©Crypton Future Media, Inc. ALL RIGHTS RESERVED
First published in Japan in 2010 by KADOKAWA SHOTEN Co., Ltd., Tokyo.
English translation rights arranged with KADOKAWA SHOTEN Co., Ltd., Tokyo
through TUTTLE-MORI AGENCY, INC., Tokyo.

English edition published by UDON Entertainment Corp.
118 Tower Hill Road, C1, P.O. Box 20008,
Richmond Hill, Ontario, L4K 0K0, Canada

Any similarities to persons living or dead is purely coincidental. No part of this publication may be reproduced, stored in retrieval systems, or transmitted in any form or by any means (electronic, mechanical photocopying, recording, or otherwise) without the prior written permission of the publisher.

www.UDONentertainment.com

Printed by Suncolor Printing Co. Ltd.
E-mail: suncolor@netvigator.com

First Printing: September 2014
ISBN-13: 978-1-926778-83-9
ISBN-10: 1-926778-83-9

Printed in Hong Kong

CREATORS INDEX

218 (Niiya)	050
Akka	010
Arisaka Ako	028
Asagiri	071
Chitose Kiiro	042
Ebisu Senri	041
Eku	048
Ekusa Takahito	033
Hakone	054
Hirara	055
Homare	036
Ichiyo Moka	024
Iroha	063
Kamijo Eri	034
Kazuharu Kina	059
Kei	004
Komei Keito	031
Kuu	012
Linco	022
Manishi Mari	045
Matsuko	040
Meola	008
Merinow	064
Milo	066
Minami	046
Nabeya Sakihana	058
Nagimiso	016
Nanzaki Iku	035

Neko	056
Nippori	068
Ontama	086
Pisuke	062
Ponjiri	038 & 119
Renta	060
Ryouno	020
Sasaki Mutsumi	030
Sayaka Gojoh	097
Shirakaba	074
Shiro	018
Shinryo Rei	014
Suzuri	032
TNSK	006
Tomoyoshi Ossan	072
Ui	026
Wasabi	044 & 109
Yamiya	052
Yuki Mizore	051
Zain	070

Cooperation
Crypton Future Media

Exit Tunes
King Record Co., Ltd.
Good Smile Racing
Sega Corporation
Sony Music Direct, Inc.
Taito Corporation
T.Y. Entertainment, Inc.
Dwango Music Entertainment, Inc.
Nippon Crown Co., Ltd.
Victor Entertainment
5pb. Inc.
Farm Records
U/M/A/A Inc.
Lantis Co., Ltd.

FLUTTER

GULP

STARE

WHAT?!

FLAP

ボカロッテ★リッチアイス
"McVocald's Rich Ice Cream"

MEI, CALM DOWN.

WHY DO YOU ALWAYS...

I SAID TO PUT SOMETHING SPECIAL IN WHEN WE WERE DOING THIS, AND YOU PUT...

カロッテ★リッチアイス

FOR A WHILE AFTER THIS, THE CALLS OF "KAITO, WE LOVE YOU!" RANG OUT.

Please let us all be able to sing like this forever!
KAITO

I'M SORRY, KAITO!!!

KAITO!!

SHE USED TO RUN AROUND CRYING, SHE WANTED IT SO BADLY.

Silly. You'll get better.

I suck! I'll never be able to sing this!

BACK THEN, SHE COULDN'T SING IT WELL.

Miku several years ago

BUT IT SEEMS LIKE SHE'S REALLY OVERCOME HER PAST.

We'll do the harmonies.

Let's sing this at our next concert!

THERE'S STILL SOMETHING LEFT IN THE CAPSULE BOX...

Meiko...

HM?

What?

SHH!

JUST LISTEN.

WHAT SONG?

CHATTER

...THAT SONG NOW?

...GOING TO SING...

SO MIKU'S...

CHATTER

FWOO

Shhhhoom

...REALLY WEIRD.

SITTING SO FORMALLY-?!

STUNNED

GASP!

HEY, MIKU?!

...THIS SONG.

DON'T "MEIKOOOO" ME. WHAT'S WRONG?

O-OH, IT'S YOU...

MEIKOOOO!

You scared me.

Rustle

YOU THINK IT'D BE OKAY IF I SANG IT NOW?

THIS SONG...

BUT IT'S STRANGE, ISN'T IT? SEEING THESE THINGS WE LOVED FROM THE OLD DAYS...

SO WHAT?

WELL, DID YOU HAVE ANYTHING ELSE YOU WANTED TO PUT IN?

...NO, BUT...

...MAKES ME SO HAPPY THAT WE'RE STILL ABLE TO KEEP SINGING JUST LIKE WE DID BACK THEN.

MIKU'S ACTING...

HEY, GUYS!

M-ME TOO!

Sniffle

AH! ME TOO-OOO!

Clutch "AN OLD RIBBON. IT'S THE ONE I ALWAYS USED WHEN I WAS FIRST STARTING OUT!"	"WHAT DID YOU PUT IN, RIN?"

"AND LEN ALSO PUT IN A RIBBON (TIE)." *Mm-hmm!* I remember!

OH!

A ribbon?

"GOODNESS! YOU AND RIN MATCH." "YOU MATCH?" *you match?* ♡

"WHAT?!"

"WHAT?! NO! RIN JUST WENT AND PUT MY TIE IN HERSELF."

Flutter

"YOU GUYS! HERE IT IS!"

"OUR TIME CAPSULE!"

time capsule — Ponjiri

"MEIKO, WHAT DID YOU PUT IN?"

"HM?"

TA-DA ★

"MY FAVORITE MIC, BROKEN."

"WOW! IT LOOKS WELL-USED!"

"OKAY THEN, PRODUCER."

"FROM NOW ON, I'LL LIVE MY LIFE SINGING FOR MY OWNERS."

"UNTIL NOW..."

"EVEN THOUGH I'M NOT MARRIED YET..."

"...UH-HUH."

"THANK YOU!"

"GO GET 'EM."

"...IT'S LIKE I'M WALKING MY DAUGHTER DOWN THE AISLE."

"IT'S A VAGUE FEELING, BUT I'M SURE OF IT."

"LUKA!"

"YOU HEAR? LUKA'S FINALLY MAKING HER DEBUT!"

"AND APPARENTLY SHE'S BILINGUAL. AMAZING!"

"THEY SAY SHE'S GOING TO BE A VOCALOID WITH AN APPEAL UNLIKE THAT OF MIKU OR RIN AND LEN!"

"BACK TO WORK TODAY."

"PRODUCER! ARE YOU SURE YOU'RE OKAY NOW?"

"IS THIS YOUR DEBUT COSTUME? DOESN'T IT EXPOSE TOO MUCH? AND THAT SLIT'S A LITTLE TOO RISQUÉ..."

"AM I SEDUCING YOU WITH MY ADULT APPEAL?"

"WHAT?!"

Staaaaare...

"DON'T GET CHEEKY! TO ME, YOU'RE STILL JUST A CHILD!"

GIGGLE

GRAR

...I'M SORRY, LUKA.

THIS IS AWFUL, ME HOLDING YOU BACK LIKE THIS...

SHAKE SHAKE

I UNDERSTAND. YOU'VE BEEN WORKING DAY IN, DAY OUT WITHOUT SLEEPING.

ALL FOR MY SAKE...

WHAT HAVE I BEEN SINGING FOR?

IF IT ONLY HURTS EVERYONE...

I SHOULD JUST...

LUKA.

PRODUCER!

JUST NOW, I THINK IT WAS PERFE--

WHIRL

SILENCE...

PRODUCER?!

"I'm fine. I can keep singing."

"I know you have a good chance of making your debut if you pass the test tomorrow, but..."

"If you don't take a break, you'll—"

"I SAID I'M FINE!!"

FWAP

"...Okay."

"We'll keep going... ...until you're satisfied, Luka."

"Thank you."

YOU CAN'T MAKE YOUR DEBUT LIKE THIS!

THE DAYS OF PRACTICE WENT ON.

I'D BE LYING IF I SAID IT WASN'T HARD, BUT...

...I'M SORRY.

I WAS OKAY WITH IT.

LOOKS LIKE RIN AND LEN HAVE THEIR DEBUT SET.

CHATTER

AND STILL ONLY FOURTEEN. INCREDIBLE.

PAT

LUKA.

DON'T WORRY ABOUT IT.

YOU HAVE YOUR OWN PERSONALITY.

YOU CAN'T COMPARE YOURSELF TO ANYONE ELSE.

......

...OKAY.

EVERY DAY WAS A JOY.

BECAUSE PRODUCER WAS ALWAYS BY MY SIDE. BECAUSE I LOVED TO SING.

I'M JUST A PROTO- TYPE, SO I DON'T HAVE A NUMBER YET...

ONCE YOU'RE GROWN UP, YOU'LL GET A NUMBER.

I'M THE VOCALOID LUKA.

AND THEN YOU'LL MAKE YOUR DEBUT AS A VOCALOID!

WE CAN DO IT TOGETHER.

YES!

RIGHT, LUKA?

PRODUCER!

HOW MANY TIMES DO I HAVE TO TELL YOU?!

HAVEN'T I SAID THAT PART DOESN'T GO LIKE THAT?!

I SING.

TODAY, I SING FOR HIM.

For Someone
Wasabi

KSSSH

ZOXX--
Transmission Complete

E N D

VOCALOID 02
MEGURINE LUKA 03

02 VOCALOID02 KAGAMINE RIN

KAGAMINE LEN

01 HATSUNE MIKU
VOCALOID 2

VOCALOID
MEIKO

VOCALOID
KAITO

revolve
Sayaka Gojoh

CD

Romeo and Cinderella
Doriko feat. Hatsune Miku
*Nov. 24, 2010 *2,625 yen
*5pb.Records
http://5pb.jp/records/

The long-awaited second album from mega-popular Vocaloid producer Doriko collects a total of 13 songs, including the ultra-famous "Romeo and Cinderella" and "Ameka Yume" ("Sweets or Dreams").
Illustration: Nezuki
(C) Nezuki
(C) Crypton Future Media
*Vocaloid is a registered trademark of Yamaha Corporation.

CD

Star of the Four Seasons
Yuyu feat. Hatsune Miku and Kagamine Rin and Len
*Sept. 15, 2010 *2,500 yen *Nippon Crown http://www.crownrecord.co.jp/

Yuyu's major label debut features 16 songs, collecting hits like "Sakura no Kisetsu" ("Sakura Season"), "Shiro no Kisetsu" ("White Season"), and "Clover Club," among others.
Illustration: Tamajam

CD

Hatsune Miku Sings Halmens
*Oct. 20, 2010 *2,000 yen *Victor Entertainment
http://www.jvcmusic.co.jp/

This official cover album was made to commemorate the 30th anniversary of Halmens' debut, and features a total of 18 songs covered by a wide variety of talented Vocaloid producers like Deadball-P and Udon Gerge.
Illustration: Nigo

JACKET VISUAL CHRONICLE 096

CD

Cinderella Summer feat. Hatsune Miku
Shota and Chuta feat. Hatsune Miku

*Jun. 2, 2010 *2,800 yen *Nippon Crown
http://www.crownrecord.co.jp/

The debut album from Shota and Chuta features a total of 12 songs, including originals like "Senko Shojo" ("Girl Batting First") and "Hoppe, Hazukashi Na" ("My Cheeks, Embarrassing, Huh"), and covers like "Hoshikuzu Utopia" ("Stardust Utopia").
Illustration: Hill Ichinohe

CD

Kimi no Iru Keshiki (A Scene with You in It)
White Flame presents feat. Megurine Luka

*Sept. 2, 2009 *2,000 yen *T.Y.Entertainment http://www.tyent.jp/

White Flame's first full major label album is a gorgeous 2-disc set that features a total of 24 songs, with the Vocaloid disc rearranging songs like "Cantarella" and "Akahitoha" ("Single Leaf").
Illustration: Ichiyo Moka

CD

Do Vocaloids Dream of the Doomsday Bird?
sasakure.UK

*Mar. 3, 2010 *3,000 yen (limited edition CD + DVD)
*U/M/A/A Inc. http://www.umaa.net/

This full major label album from talented artist sasakure.UK features 17 songs, including favorites like "*Hello, Planet" and "Bokura no 16bit Senso" ("Our 16-bit War").
Illustration: ChaKoro

CD

The Theory of Mutual Love
Deco*27

*Apr. 21, 2010 *3,000 yen (limited edition CD + DVD)
*U/M/A/A Inc. http://www.umaa.net/

The major label debut from Deco*27, another talented artist, contains 18 songs, including hits like "Nisoku Hoko" ("Breathe My Breath") and "Aikotoba" ("Words of Love").
Illustrator: Ryono

095 | JACKET VISUAL CHRONICLE

CD

The Disappearance of Hatsune Miku
cosMo@Boso-P feat. Hatsune Miku
*Aug. 4, 2010 *2,000 yen
*EXIT TUNES
http://www.hatsunemikushoushitsu.com/

cosMo@Boso-P's first major label album is a concept album tracing the disappearance of Hatsune Miku and includes the first full version of "Hatsune Miku no Gekisho" ("Hatsune Miku's Sudden Song"), for a total of 14 songs.
Illustration: Hidari

CD

Kocchi Muite Baby/Yellow
*Jul. 14, 2010 *1,575 yen (regular edition), 1,890 yen (limited edition)
*Sony Music Direct http://www.sonymusic.co.jp/

This split single features "Kocchi Muite Baby" ("Over Here, Baby") (ryo (supercell) feat. Hatsune Miku) - previously seen only in the PSP game Hatsune Miku: Project DIVA 2nd - and "Yellow" (kz (livetune) feat. Hatsune Miku), for a total of four songs.
Illustration: Uki Ayatsu

CD

Cinnamon Philosophy
Oster Project feat. Hatsune Miku
*Oct. 27, 2010 *2,625 yen *5pb.Records http://5pb.jp/records/

The second album from super-famous Vocaloid producer Oster Project is packed with a total of 17 fantastic songs, including "Yuki Usagi" ("Snow Bunny") and "Trick and Treat".
Illustration: Y-oji
© Y-oji
© Crypton Future Media
*Vocaloid is a registered trademark of Yamaha Corporation.

JACKET VISUAL CHRONICLE 094

CD
VocaL@ntis
Hatsune Miku Sings Lantis Standards
*Aug. 25, 2010 *3,000 yen *Lantis http://www.lantis.jp/

This official compilation album features the Vocaloids singing Lantis label songs like "Motteke! Serafuku" ("Take the Sailor Costume!") and "Harebare Yukai" ("Sunny and Relaxed").
Illustration: Bania 600

CD
Vocaloid Love Songs ~Girls Side~
*Sept. 22, 2010 *2,525 yen
*MOER http://ch.nicovideo.jp/channel/ch189

An album with the concept "for the girls", this CD brings together a total of 14 songs talking about love, like "Koiiro Byouto" ("Love Ward"), "Yubikiri" ("Pinkie Promise"), and "Discommunication".

CD
VL-SCRAMBLE
*Mar. 24, 2010 *2,000 yen
*King Records http://creativerun.com/

The first compilation album from Creative Run Recordings features 11 songs from 11 creators, including "Mikaduki Rider" ("Crescent Moon Rider") and "Unbalance".
Illustration: Guiter (Gita)

CD
Moer feat. Hatsune Miku
2nd Anniversary
*Aug. 11, 2010 *2,000 yen *MOER http://ch.nicovideo.jp/channel/ch189

To celebrate the second anniversary of the Moer label, this compilation album brings together a total of 15 songs both new and on CD for the first time, including "Story" and other representative works from each creator.

CD

EXIT TUNES PRESENTS
Vocalogenesis feat. Hatsune Miku
*Jul. 21, 2010 *2,000 yen
*EXIT TUNES http://www.vocalogenesis.com/

This legendary compilation album captured the top spot in the Oricon weekly charts for the first time in Hatsune Miku's history and collects 19 songs, including the first major label releases of "Migikata no Cho" ("Butterfly on My Right Shoulder") and "Iroha Uta" ("Alphabet Song").
Illustration: Miwa Shiro

CD

Vocarock Collection feat. Hatsune Miku
*Jul. 21, 2010 *2,000 yen *FARM RECORDS http://www.farm-records.com/

Focusing mainly on rock songs, this compilation album features such popular songs as "World's End Dancehall", "Monochroact", and "Palette", for a total of 16 songs.
Illustration: Nagimiso

CD

EXIT TUNES PRESENTS
Vocaloanthems feat. Hatsune Miku
*Sept. 15, 2010 *2,000 yen *EXIT TUNES http://vocaloanthems.com/

This compilation album brings together a total of 18 songs, including hits like "Just Be Friends" and "Ore no Road Roller Da!" ("It's My Road Roller!"), and took No. 5 on the Oricon weekly charts.
Illustration: redjuice

JACKET VISUAL CHRONICLE 092

CD

**Hatsune Miku: Project DIVA 2nd
NONSTOP MIX COLLECTION**

*Jul. 28, 2010 *2,940 yen *Sony Music Direct

Released in advance of the PSP game Hatsune Miku: Project DIVA 2nd, this official compilation album features nonstop mix versions of 26 select songs, including "Kocchi Muite Baby" ("Look Over Here, Baby").

CD/DVD/Blu-ray

**Miku Day Appreciation Festival
39's Giving Day / Project DIVA presents
Hatsune Miku Solo Concert
Good Evening, I'm Hatsune Miku!**

*Sept. 1, 2010 *7,350 yen (Blu-ray), 6,300 yen (DVD), 3,150 yen (CD), 3,990 yen (UMD)

This live CD/DVD/Blu-ray is a recording of Hatsune Miku's legendary first concert at Zepp Tokyo on March 9th, 2010, and features two hours of Vocaloid concert magic, filled with all the excitement of a live show!
©SEGA
©Crypton Future Media, Inc.
*Vocaloid is a registered trademark of Yamaha Corporation.

CD

**Hatsune Miku: Project DIVA
Original Song Collection**

*Jul. 22, 2009 *3,000 yen *Lantis

This album, released at nearly the same time as the PSP game Hatsune Miku: Project DIVA in 2009, collects only the new songs for the game, for a total of 13 songs including "Tengaju Arabesque" ("Velvet Arabesque") and "Rabu Risuto Koshinchu?" ("Love List Updating?").
(Illustration: Kei)

CD

**Hatsune Miku: Project DIVA Arcade
Original Song Collection**

*Jul. 7, 2010 *2,000 yen

The official album for Hatsune Miku: Project DIVA Arcade collects a total of 13 songs submitted by the public, such as "Doshite Ko Natta" ("How Did This Happen") and "Disruptive Diva."

091 JACKET VISUAL CHRONICLE

JACKET VISUAL CHRONICLE

We picked out the best of the jacket illustrations for Vocaloid CDs, DVDs, and games to display in this section! It goes without saying that these illustrations, drawn by incredibly skilled artists, are full of vibrant individuality, and we've even included some recent ones that make full use of 3D and photo-realistic styles for a seriously varied lineup!

Produced by Sasaki Wataru (Crypton Future Media)
All voice material by Fujita Saki (Artsvision)
Hatsune Miku original illustration by Kei
Miku (zero-vocalist version) design by Asai Masaki
Miku's old logo processing/Visual effects and mix by Nekoita
Miku Append and D.B. image logo by Naoya Miyadai (opticalflats)
(C) Crypton Future Media, Inc.
*Vocaloid is a registered trademark of Yamaha Corporation.

SOFT **Hatsune Miku Append**
*Apr. 30, 2010 *16,800 yen *Crypton Future Media

For the package art for this expanded voice pack featuring a new vocal library for Hatsune Miku, sculptor/modeler Asai Masaki created a figure and Nekoita made this illustration based on its design, for a piece of art that was only completed after a labor-intensive process.

*All prices include 5% tax (as of October 2010).

Leaping beyond the framework of the product... fly, Vocaloids!

Collaboration #2
Hatsune Miku × Music GunGun! Super Song Super Extra Version!
GAME

Our diva swings down to join in this fun rhythm shooting game!

Hatsune Miku appears as a guest character in Music GunGun! Super Song Super Extra Version!, the 2010 version of this rhythm shooting game in which players shoot at enemies one after another in time with the music playing. As in the original game, Miku is in costume as an officer of the Muse Police, and when players choose a Hatsune Miku song during the game, she shows up before the song starts.

What's "Music GunGun!"?

This rhythm shooting game has players shooting at enemies with a gun controller in time with the music playing. Ever since the first version was released in arcades in July 2009, this game has been generating a huge following. The game features more than 90 songs, including the secret tracks.

Super Song Super Extra Version! was released of Nov. 2010.

Collaboration #3
Hatsune Miku × Good Smile Racing with Cox
RACING TEAM

Miku hits the road and puts the pedal to the metal!

The Hatsune Miku GT Project put Miku in the seat of a GT car. In 2010, their third year, the racing team Good Smile Racing with Cox took part in the Super GT300 class. "Racing Miku" was drawn on the body of the team's machine, a Porsche 911 GT3R, as the concept character. The sight of Miku's beautiful figure whizzing by was, in a word, incredible. Not only that, the team's race queens dressed up in Miku costumes as "Racing Miku Supporters". Does all of this mean that Miku has crossed over into the real world?!

What's "Good Smile Racing with Cox"?

Good Smile Racing, a manufacturer involved in high-quality mini-cars among other things, joined up with Cox as a partner to create a racing team. The team competes with a 911 GT3R, the only 2010 model Porsche provided. Just like the team concept of "a racing team powered by the fans" says, the team has a sponsorship system that allows individuals to sponsor them, giving the team the support of many fans.

The Racing Miku illustration on the body of the Porsche 911 GT3R! On the front, the sides... wherever you look, Miku is there to delight fans.

*1/43 mini-cars on sale now

Racing Miku

Hatsune Miku Collaborations

As the electronic diva who launched a massive movement, Hatsune Miku has naturally had many opportunities for collaboration with other productions. Rather than just singing, she is branching out into many other activities. Here we take a look at a few of Miku's planned collaborations, with the diva herself taking part in a variety of ways.

What's "Lucky Star"?

This 4-panel manga by Kagami Yoshimizu has been serialized in Comptiq (Kadokawa Shoten) since January 2004. Currently, it's also being serialized in Comp-Ace (Kadokawa Shoten), among other magazines. First made into a video game in 2005, the comic was also adapted into an animated series in 2007. The model for the shrine that appears in the show, Washinomiya Shrine - a so-called sacred pilgrimage spot - has become so popular that there is now a variety of events held there to revitalize the local area.

Kagami Yoshimizu original illustration

The collaboration with the popular comic realized at last!

The comic Lucky Star, currently serialized in Comptiq (Kadokawa Shoten) to rave reviews, has been collaborating with Miku for some time now; one character, Kagami Hiiragi, appears in the OVA cosplaying as Miku, and a figure of that cosplaying Kagami was released for sale. Also, the May 2010 issue of Comptiq came with a new version of Mikku Miku Kagami and an illustration for a special pillowcase. This led to the debut of the spring-like, cherry blossom-inspired Sakura Kaga Miku.

Collaboration #1

Hatsune Miku × Lucky Star

Kagami Hiiragi dresses up as Hatsune Miku and Miyuki Takara as Toeto (a Megurine Luka-derived character).

COMIC

Sakura Kaga Miku

SPECIAL PILLOWCASE

©美水かがみ / 角川書店

FUN

"HACHUNE MIKU'S DAILY LOIPARA!" IS CURRENTLY BEING SERIALIZED WITH GREAT REVIEWS IN COMP-ACE.

Panel 1:
- EXACTLY! NOTHING TO GET WORKED UP ABOUT.
- UNNNH
- NO NEED TO GET DOWN ABOUT IT.

Panel 2:
- YOU GUYS...
- IF YOU KEEP GOING, YOU'LL JUST NATURALLY GET BETTER.
- IF YOU'RE HAVING FUN, THAT'S ALL THAT MATTERS.
- SNIFFLE

Panel 3:
- GOT IT! I WILL HAVE FUN DRAWING!
- YEAH! YEAH!

Panel 4:
- YOU CHANGE YOUR MIND TOO FAST!
- AND I'LL BE A 4-PANEL MANGA ARTIST!
- HEE HEE HEE
- WHY?!

4-Panel Introduction

RIVALS

Panel 1:
- OH MY! THAT'S REALLY CUTE!
- SO?! PRETTY GOOD, HUH?
- HEH HEH

Panel 2:
- GAH?!
- SO?!
- BUT YOUR RIVAL IS RIGHT HERE.

Panel 3:
- WHAT?!
- HI-TECH?
- 'CAUSE LEN CAN DRAW USING A COMPUTER.
- TA-DA

Panel 4:
- WHAT IS THAT?!
- INCREDIBLE!
- LUKA, YOU GOTTA...

HACHUNE MIKU'S DAILY LOIPARA!

PURPOSE

Hachune Miku's Daily LOIPARA!

ALRIGHT!

DID LOOKING AT THAT BOOK INSPIRE YOU?

I'M GONNA BE AN ARTIST!

THAT'S SUDDEN!

YEAH! THE PICTURES I DRAW...

SO YOU HAVE A NEW PURPOSE?

THAT'S WEIRDLY PRACTICAL.

AKITA NEW RICE, OKAY!!

THEY'RE GONNA BE ON PACKAGES OF RICE AND ALCOHOL!

TA-DA

PRESENTED BY ONTAMA

Popular and cute! Hatsune Miku makes her arcade debut!

Fairy

Kitty

Miko

Append Miku

Natural

White One-Piece

Module Gallery

In addition to the modules from the first PSP game, new modules are also available. Don't miss any!

AC GAME
Hatsune Miku: Project DIVA Arcade
- Available now
- 1 game/100 yen and up *SEGA
- Rhythm action game

Project DIVA Arcade

New songs are actively sought out by the developers, and if they are adopted, they're sent to the arcade machines. This game is a collaboration with the fans!

Although the screen layout itself is different, the appeal of playing against the video backgrounds is the same, and with a higher resolution than on the PSP.

Miku finally appears in arcades!
The Project DIVA series has stepped into the arcade world. Players use the arcade cabinet's large buttons to tap to the rhythm, and must master new techniques like simultaneous button-pressing and holding single buttons down for longer notes. With new songs available for limited times and the chance to get new modules through player registration via IC cards, Project DIVA Arcade feels more like an event than just a game! This is a must-play for fans of this amazing series!

Strange Diva Collaboration! The iDOLM@STER SP Costumes!

Primary Plum

The iDOLM@STER costumes are a dream collaboration between The iDOLM@STER SP (Bandai Namco Games) and Miku. Enjoy them in the game as the Primary Plum module.

Kagamine Rin feat. Ami and Mami

Megurine Luka feat. Chihaya

Hatsune Miku feat. Haruka

Illustration by Tamura Hiro

This module is available as downloadable content. In addition to the module, there are also items and new songs available for purchase.

What kind of game is Hatsune Miku: Project DIVA 2nd? (2)

Thanks to the addition of duets in this game, you can now set up the movements for two Vocaloid characters and create even more captivating videos.

You can control not just character movements, but also practically every detail of the video itself, such as the camera, blinking, mouth movements, and effects.

An Edit Mode that's even easier to understand, with much more freedom!
Edit Mode allows you to create your own original videos based on the MP3 song data you have on your PSP. Giving players the opportunity to create gorgeous videos with Miku and the gang using their favorite songs, this mode shines as its own separate game and was a popular part of the first Project DIVA. This time, the rhythm options and settings are even easier to understand, and players have a large degree of freedom in entering the lyrics and selecting other options. Why not try it out and make a music video you can call your own?

Kaito

- Kaito Swimwear V AS
- Cyber Cat (SEGA/Piapro collaboration)
- Campus (SEGA/Piapro collaboration)
- Classic (SEGA/Piapro collaboration)

Sakine Meiko
- Black Dress

Yowane Haku
- Cyber Drive

Akita Neru
- Ethnic

HATSUNE MIKU: PROJECT DIVA ARCHIVE

Megurine Luka

Hard Rock
(SEGA/Piapro collaboration)

Fraulein
(SEGA/Piapro collaboration)

Chiffon Dress
(SEGA/Piapro collaboration)

Luka Flower
(SEGA/Piapro collaboration)

Meiko

Modern Girl AS

Modern Girl
(SEGA/Piapro collaboration)

Scarlet
(SEGA/Piapro collaboration)

Fluffy Coat
(SEGA/Piapro collaboration)

HATSUNE MIKU: PROJECT DIVA ARCHIVE 082

Kagamine Rin

Cute Rin
(SEGA/Piapro collaboration)

Reactor
(Designed by Nagimiso)

Cheerful Candy
(Designed by nezuki)

Asymmetry R
(SEGA/Piapro collaboration)

Asymmetry L
(SEGA/Piapro collaboration)

Kagamine Len

School Jersey
(SEGA/Piapro collaboration)

Punkish
(SEGA/Piapro collaboration)

Pink Pops
(SEGA/Piapro collaboration)

Saihate Miku
(Designed by Kobayashi Onikisu)

Angel
(SEGA/Piapro collaboration)

Pink Pops AS

Append Miku

∞
(Designed by cosMo@Bosou-P)

Colorful Drop
(Designed by nezuki)

HATSUNE MIKU: PROJECT DIVA ARCHIVE 080

Powder
(SEGA/Piapro collaboration)

Noble
(SEGA/Piapro collaboration)

White One-Piece
(SEGA/Piapro collaboration)

Natural
(SEGA/Piapro collaboration)

Spacy Nurse
(SEGA/Piapro collaboration)

Cute Miku
(SEGA/Piapro collaboration)

Aile d'ange
(SEGA/Piapro collaboration)

079 HATSUNE MIKU: PROJECT DIVA ARCHIVE

Module Gallery

Project DIVA 2nd adds many more modules (costumes) for the Vocaloids to wear, bringing the total up to nearly one hundred. Take a look at some of these glamorous modules right here!

Hatsune Miku

Spiritual
(Designed by KEI)

Miku Butterfly
(SEGA/Piapro collaboration)

Vintage Dress
(SEGA/Piapro collaboration)

Jer*Sey
(SEGA/Piapro collaboration)

Yellow
(Designed by redjuice)

Miku Hood
(SEGA/Piapro collaboration)

Stroll Style
(SEGA/Piapro collaboration)

HATSUNE MIKU: PROJECT DIVA ARCHIVE

初音ミク Project DIVA 2nd

The latest Hatsune Miku rhythm game powers up with more videos and more songs for an even more gorgeous game!

PSP GAME
Hatsune Miku: Project DIVA 2nd
*On sale now *6,090 yen (tax incl.)
*SEGA *Rhythm action game
http://miku.sega.jp/

Kagamine Rin and Len
Their bodies may be small, but their voices are big! Their almost yellow-orange hair and their sailor uniforms are their trademarks. With this game, they join the fun in the DIVA Room.

Megurine Luka
A Vocaloid with an adult sensibility. With her fair skin and pink hair, she gives the impression of a relaxed older sister. She is also newly available in the DIVA Room.

Hatsune Miku
An electronic diva who makes an instant impression with her blue-green hair and super-long pigtails. As she is the protagonist of this series, you can catch a glimpse of this cutie's everyday life in the DIVA Room.

Power up for super volume and response! In this follow-up to last year's smash-hit rhythm game Project DIVA, the number of songs and modules has dramatically increased, and players have even more freedom in the video creation mode. Additional songs are also available as downloadable content, expanding the range of fun you can have!

The second Hatsune Miku rhythm game, with everything powered up!

What kind of game is Hatsune Miku: Project DIVA 2nd? (1)

The videos that were so popular in the last game are back and better than ever. Hit the buttons with good rhythm and experience a real, live performance!

With new gameplay techniques like holding a button for a long time and simultaneous button-pressing, you feel like you're really singing and dancing with Miku and the gang.

Give gorgeous performances with the most popular tunes -- including new songs!
In the main "rhythm game" mode, players press buttons at just the right time to match the icons flowing across the screen against a music video-like background. The basic rules are the same as last time; for example, when the gauge empties because of too many mistakes, it's game over. But this sequel reveals a variety of new elements, including advanced techniques like holding a single button for a long time and pressing multiple buttons simultaneously, as well as help items. Players can also choose from four levels of difficulty now, making this new game seriously meaty.

Send this voice out into space!

Playing with Miku on stage at an even higher level...

Hatsune Miku: Project DIVA Archive

EVEN MORE NEW GAMES STARRING THE ELECTRONIC SINGING DIVA!

Miku's video game debut, Project DIVA - a rhythm game in which you press buttons in time with the music - was an instant hit when it was released in 2009, and since then, additional content has been added and new games released. An arcade version has even come out, bringing the series to a whole new audience. Let's take a look at two of the best games in the Project DIVA series!

Hatsune Miku made her striking video game debut last year, and since then, she has already appeared in new Project DIVA series games. Welcome to Miku's game world, growing larger all the time!

Illustration by KEI

©SEGA ©Crypton Future Media, Inc.
VOCALOID はヤマハ株式会社の登録商標です。

HATSUNE MIKU: PROJECT DIVA ARCHIVE 076

VOCALOID EXTRAS

Vocaloid Extras

With games, CDs, DVDs, collaboration products, and more, the Vocaloids' world is limitless!

CREATOR No.039

shirakaba

I wake up, go to bed, draw, everything while listening to Miku's songs.

web site bonenod http://srkb.nobody.jp/

Artist comments
1. Dinner Table at the Hatsune House: Clean up your desktop!
2. Santa Miku: Santa Miku basically gives out onions for presents!

VOCALOID CREATORS ILLUSTRATION GALLERY Part2 074

073 VOCALOID CREATORS' ILLUSTRATION GALLERY Part 2

CREATOR No.038

Ossan here. Hatsune Miku doesn't have any specific setting, so each time I draw her I get to make her do what I want, which is a lot of fun. I'm grateful to Hatsune Miku for the wonderful encounters and discoveries she's brought me.

Tomoyoshi Ossan

website None

Artist comments
1. Illustration posted on Piapro
2. Illustration posted on Piapro
3. Doujinshi "Aomidori Gekijo Vol. 1" ("Turquoise Theater Vol. 1") cover illustration
4. Makkoi song "Heya" ("Room") video illustration
5. X-Plorez song "Mikunologie" video concept art
6. Illustration posted on Piapro
7. Illustration posted on Piapro
8. "Hatsune Miku: Project DIVA 2nd" Now Loading screen illustration

VOCALOID CREATORS' ILLUSTRATION GALLERY Part 2 072

CREATOR No.037

Asagiri
website None

My name's Asagiri. I'm an illustrator with a weakness for girls and mecha. I'm currently accepting illustration work, so if you're interested, please contact me at asgr5511@yahoo.co.jp.

Artist comments
1. Illustration provided for the video for a certain Hatsune Miku song.
2. I thought she would look good with a mecha.
3. A cute environment suits this energetic girl.

VOCALOID CREATORS' ILLUSTRATION GALLERY Part 2

CREATOR No.036

I like pictures full of vibrant colors.

Zain

web site nananananana http://777nnn.jugem.jp/

Artist comments
1. Station428
2. Monitoring now
3. Analyze the Data
4. Miku to Miku
5. Singing and Listening

VOCALOID CREATORS' ILLUSTRATION GALLERY Part 2 070

"Sakine Meiko"
咲音メイコ

VOCALOID CREATORS' ILLUSTRATION GALLERY Part 2

CREATOR No.035

Nippori

Long live Hatsune Miku! Long live Meiko! Make it to 40, Kaito!

website POO'S WORLD http://www.cablenet.ne.jp/~amumu/

Artist comments
1. Onion Dance: Panel drawings of the animation I uploaded to Nico Nico Douga
2. Kai/Mei: Uploaded to Piapro
3. Box Drawing: Uploaded to Pixiv
4. Izakaya: Uploaded to Piapro
5. Dreams Revealed in the Night: Uploaded to Pixiv
6. Sakine Meiko: Uploaded to Piapro
7. Hand-Me-Downs: Uploaded to Pixiv

VOCALOID CREATORS' ILLUSTRATION GALLERY Part 2 068

067　VOCALOID CREATORS' ILLUSTRATION GALLERY Part 2

CREATOR No.034

Milo

Hello. My name's Milo. I have fun making videos for the Vocaloid songs I like with paper and clay on Nico Nico Douga.

website Crumbs are Good Too. http://nicomilo.blog75.fc2.com/

Artist comments
1. From CaptainMira-P's "Dokotonaku Nantonaku" ("Somewhere Somehow")
2. From Kuchibashi-P's "Ex-Girl"
3. Miku the witch in a good mood
4. From Daniwell-P's "Nekomimi Switch" ("Cat Ear Switch")
5. From Lovely-P's "Waribashi Onna" ("Split Chopsticks Girl")
6. From Travolta-P's "Toeto" and inspired by Nagimisosan's illustration

VOCALOID CREATORS' ILLUSTRATION GALLERY Part 2 066

065　VOCALOID CREATORS' ILLUSTRATION GALLERY Part 2

CREATOR No.033

Merinow

Vocaloid pictures are a lot of fun since even for the same characters, you can match the emotion of their voice and the music to draw a bunch of different kinds of moods.

web site Black and White Delta http://www2.pure.cc/~wmerino/

Artist comments

1. Posted on website. The blue of Snow Miku is cute, so I tried drawing a blue regular Miku.
2. Posted on website. I was attracted to the song of the same title, so I did a concept illustration for it.
3. Posted on website. I wanted to do something with green as the main color, so I put some plants into this drawing.
4. Posted on website. I love the video for this song way too much, so I just had to draw it.
5. Posted on website. This picture is the first one I did of Megurine Luka.
6. Illustration for the "Pygmalion" video. This is a picture I was given the chance to draw for a video.
7. Illustration for the "S.K-y In the Black Space" video. This is a picture I was given the chance to draw for a video.

CREATOR No.032

Iroha

website Apr9 http://pontium.dib.jp/~unyun/

Hi there, I'm Iroha. It's already been three years and a few months since I met Hatsune Miku at Nico Nico Douga... I'm still totally addicted to the Vocaloids!

Artist comments

1. Published in Comic Market 79 doujinshi
2. Posted on illustration SNS
3. Posted on illustration SNS
4. Published in Comic Market 79 doujinshi
5. Posted on website

CREATOR No.031

Pisuke

The Vocaloids are a must-have for drawing. I listen to their amazing songs and voices all the time; they give me energy.

website Cocoronica http://cocoronica.moo.jp/

Artist comments
1. Posted on website
2. Collected in the doujinshi "Premiere"
3. Collected in the doujinshi "Premiere"
4. Posted on website
5. Posted on website

VOCALOID CREATORS' ILLUSTRATION GALLERY Part 2 062

I'll sing a song that never ends.
オワラナイウタヲウタオウ

Wander Last ＊ sasakureP

061 VOCALOID CREATORS' ILLUSTRATION GALLERY Part 2

CREATOR No.030

I love the songs and personalities of all the Vocaloids! I'm particularly into the two Kagamines. Rin and Len are the best!

Renta

website Deja-vu http://detectiver.com/

Artist comments
1 Akuyurin song "Neji to Haguruma to Pride" ("Screw, Gear, and Pride") jacket picture
2 Posted on website.
3 Posted on website.
4 Posted on website.
5 Posted on website.
6 Yandere-P song "Yotei no Mori" ("Forest of the Young Emperor") video picture
7 Posted on website.

VOCALOID CREATORS' ILLUSTRATION GALLERY Part 2 060

CREATOR No. 029

Kazuharu Kina

web site Me and You and an Imaginary World http://usamimi.info~/kazuki/

I mostly draw illustrations of girls. My name is Kazuharu Kina. I feel like about 80% of my drawings are basically of girls with black hair.

Artist comments
1. I drew this to commemorate Luka's release.
2. I drew this for my blog for Miku's sixteenth and 24-month birthday.
3. I drew this with a certain song in my mind and with the idea of a pink skirt and flowers in her hair.
4. This is an illustration I posted on my website.

CREATOR No.028

I'm an illustrator, mainly drawing by hand with Copic markers. For the most part, people buy my original drawings.

Nabeya Sakihana

website DRESSMASH http://pixiv.cc/pamvary/

Artist comments

1. Illusive Saviors: I drew this piece especially for this book. The piece shows an original worldview and clothing.
2. Megurine Luka: In January 2009, I fell in love with Megurine Luka at first sight and drew this picture. I gave the original to someone who would take good care of it.
3. Song for a Dream: I drew this piece especially for this book. I was working to express a sense of ennui.

VOCALOID 2 01
HATSUNE MIKU

VOCALOID 02-2
KAGAMINE RIN

VOCALOID 02-2
KAGAMINE LEN

VOCALOID CREATORS' ILLUSTRATION GALLERY Part 2

CREATOR No.027

Neko

I'm really delighted to be taking part in such a great art book. When I listen to Vocaloid songs, the urge to create just bubbles up in me!

web site Summer color classic http://417912.blog.33.fc2.com/

Artist comments
1. Posted on website.
2. Posted on website.
3. Posted on website.
4. Posted on website.
5. Posted on website.

CREATOR No.026

Hirara

web site New heaven and earth! http://aitenhimegimi.web.fc2.com/

My favorite of all the Vocaloids is Miku!

MIKU HATSUNE

VOCALOID

Artist comments
1. Work posted on Pixiv and Tinami
2. Work posted on Pixiv and Tinami
3. Work posted on Pixiv and Tinami
4. Work posted on Pixiv and Tinami

CREATOR No. 025

Hakone

So, give some kind of comment... That's what I'm supposed to do, but I'm stuck; nothing's coming to mind. Uh, when I think of Rin, my heart starts pounding!

web site No site name http://hakone-net.jugem.jp

Artist comments
1. Vocaloid song "Melancholic" fan art
2. Doujin CD "Higanbana, Beni, Ichirin" ("Red Spider Lily, Red, One") previously unpublished illustration
3. Doujin CD "Neko-Mimi-Ku" ("Cat-Ear Town") previously unpublished illustration

VOCALOID CREATORS' ILLUSTRATION GALLERY Part 2 054

053 VOCALOID CREATORS' ILLUSTRATION GALLERY Part 2

CREATOR No.024

Nice to meet you. I particularly like Miku and Luka.

Yamiya

web site Hatoya http://hatoya613.web.fc2.com/

Artist comments
1. Posted on website.
2. Posted on website.
3. Posted on website.
4. Posted on website.
5. Posted on website.

VOCALOID CREATORS' ILLUSTRATION GALLERY Part 2 052

CREATOR No.023

Yuki Mizore

website HEAVENLY GARDEN http://WWW.II.em-net.ne.jp/~heavenly/

As you can see, I only draw Luka. My name's Yuki Mizore. I'm on the fickle side, busy with things like putting out Vocaloid doujinshi. I love Luka like crazy.

Artist comments

1. This is a cover illustration for the winter Comic Market at the end of 2010 (Comic Market 79). But I actually finished it in June 2010, way ahead of schedule (laughs). The reason for that is I made it as the cover for a book that was supposed to be out for the summer Comic Market (C78), but the book wasn't done in time, so I decided to put it out as a cover for the winter Market.

2. This is an illustration I did for Voc@loid M@ster 7 (February 2009). Luka had just come out and I remember giving this drawing everything I had. The lines were drawn analog and the coloring was done in Photoshop. Used for the video "Su-Su-Su-Su-Suki, Daisuki: Ozei de Kaite Utattemita".

3. This is something I drew for a postcard that was handed out to attendees of Comic Market 77 at the end of 2009. I remember drawing it while frantically taking care of things before the end of the year. From around this time, I was doing lines and coloring with SAI.

CREATOR No.022

I listen to the Vocaloids every day and never get tired of them. So strange! This is the first time I've ever felt totally compelled to draw while listening to music. Thanks for all the great inspiration!

218 (Niiya)

website 218illustrations http://218.guhaw.com/

Artist comments
1 Posted on website.
2 Posted on website.
3 Posted on website.

VOCALOID CREATORS' ILLUSTRATION GALLERY Part 2 050

049　VOCALOID CREATORS' ILLUSTRATION GALLERY Part 2

CREATOR No.021

Eku

I love Miku and the Kagamines and Mori Girl fashion! One of my dreams is to make a Vocaloid illustration book!

website Stellar dots http://muu.in/desire

Artist comments

1. Doujin CD "Yosenabe 2" ("Stewpot 2") jacket
2. KarenT's summer song "Negi-sama! Bravo" jacket
3. Doujin CD "Yosenabe 3" ("Stewpot 3") jacket
4. Illustration posted on Piapro
5. Illustration posted on Piapro

VOCALOID CREATORS' ILLUSTRATION GALLERY Part 2

CREATOR No.020

Minami

Hi there, my name's Minami. I live a lazy life, drawing manga and illustrations and things. Feel free to also check out the Chibi Miku series I'm currently posting online.

website Colorful Palette http://carafuru.web.fc2.com/

Artist comments
1 Posted on website.
2 Posted on website.
3 Posted on website.
4 Posted on website.
5 Posted on website.
6 Posted on website.

CREATOR No.019

Manishi Mari

web site Mayo Mayo. http://mayo-mayo.sakura.ne.jp/

Hi there! My creative juices get flowing just looking at Miku and Rin, and I want to dress them up in all these different clothes and make them play. Onion love!

Artist comments
1. Previously unpublished
2. Illustration posted on my website
3. Doujinshi "Love Negi?" afterword illustration
4. Illustration posted on my website
5. Previously unpublished

CREATOR No.018

Wasabi

I am surprised each and every day at the endless depths of the Vocaloid world. How far can you go, Mikku Miku?

web site W.label http://sekai.gozaru.jp/

Artist comments
1 Definitely onion-flavored.
2 This is Miku in her flower-arranging costume.
3 I had the idea of a church at Christmas. I used a Christmas tree as the motif for the dress.

VOCALOID CREATORS' ILLUSTRATION GALLERY Part 2 044

CREATOR No.017

I just want to applaud the power that has pushed Miku all this way: the love of the people around her.

Chitose Kiiro

website epirca http://epirca.com/

BURNABLE GARBAGE MON/WED/FRI

UNBURNABLE GARBAGE EVERY TUES.

Artist comments

1. This was uploaded to my site as fan art. (Website)
2. "One year old but still a baby, J/K"; illustration for Hatsune Miku's first birthday. (Website)
3. An illustration I did for my website, but it was so well received that I used it as is for the cover of a doujinshi.
4. Illustration from when the meme "What's Rin got" was popular, immediately before Kagamine Rin was released. It totally freaked me out when the Kagamines were released as twins. (Website)
5. Illustration for Baker's "Carol" video.
6. Fan art published in *DTM Magazine*.

VOCALOID CREATORS' ILLUSTRATION GALLERY Part 2 042

CREATOR No.016

Ebisu Senri

I'm so happy to have been able to come across so many wonderful songs since Hatsune Miku was released, and I'm delighted to be inspired by them and draw my illustrations. A spiral of happiness!

web site Home of a Mountain Hermit http://ebisen.biz/

Artist comments

1. Image of Rin I drew for my website because I love the song "Niji-iro Paretto" ("Rainbow Palette")
2. Illustration provided for a video
3. Illustration for postcard to be handed out at a display of new products
4. Doujinshi "Kanade" cover illustration
5. Doujinshi "Even Foolish Children Want to Sing 2" cover illustration

041 VOCALOID CREATORS' ILLUSTRATION GALLERY Part 2

CREATOR No.015

Matsuko

website nia http://nia.xii.jp/

Before I even realized it, my whole life was about listening to Vocaloid songs, so I decided to draw them and make doujinshis.

Artist comments

1. Website illustration
2. Website illustration
3. Website illustration
4. Postcard to hand out at doujin event
5. Postcard to hand out at doujin event

VOCALOID CREATORS' ILLUSTRATION GALLERY Part 2　040

VOCALOID
03-LUKA

CREATOR No.014

Thank you so much for allowing me to be a part of this. All of the Vocaloid characters are so cute, and it's so much fun to draw them.

Ponjiri

website Junjo Alice http://neena.ojaru.jp/

Artist comments
1. "Genzai to Mirai no Dilemma" ("Dilemma of the Future and Original Sin") collaboration
2. Published online
3. Doujin postcard. Diva 2nd Red Riding Hood module.
4. CMPV collaboration video
5. Published online

VOCALOID CREATORS' ILLUSTRATION GALLERY Part 2 038

VOCALOID CREATORS' ILLUSTRATION GALLERY PART 2

Vocaloid Creators' Illustration Gallery Part 2

A detailed look at some of the best pieces from popular creators, complete with comments!

website FOOL's ART GALLERY http://fool.ran-maru.net/
Illustrator from Kumamoto prefecture. Active in many fields, including video games, books, and card games, portraying a variety of characters. Works include *Castle of Shikigami III* and *Phantasy Star Portable 2*.

Homare

Nanzaki Iku

web site None

Manga artist from Tokyo who still doesn't have Internet access. Works include *Queen's Blade: Hide & Seek* among others. Became obsessed with the Vocaloids after catching sight of Luka in a magazine. Currently shipping "Negitoro" as a couple.

HATSUNE.MIKU VOCALOID 01
illustration : eri kamijo

Kamijo Eri

web site digipop http://digipop.to
Illustrator living in Hokkaido. Involved in a wide variety of activities and works on illustrations for book covers, games, credit cards, CD jackets, and cell phone wallpaper. 2011 day planner "Butterflies & Music" (Delfino) now on sale.

Ekusa Takahito

website EXA'S PICATA http://picata.net
Character designer from Nagano Prefecture. Involved in many different works in the world of manga, anime, and games. In addition to representative work "Binchotan" being adopted as the mascot for the Minabe Forest Association in Wakayama Prefecture, Takahito's illustrations contribute to the revitalization of regional areas.

web site Tennenseki http://www.ye4.fiberbit.net/tennenseki/
Illustrator from Kanagawa Prefecture. Hobby is Airsoft. Mainly does concept art for girls' games, but also contributes illustrations to magazines and comics.

Suzuri

Komei Keito

website Genten Kaiki http://www7.plala.or.jp/koumekeito/
Freelance manga artist and illustrator. In addition to working on game concept art and character design, is also involved in the manga adaptations of the famous works *Kujibiki Unbalance* and *Spice and Wolf*.

Hatsune Miku Tribute Illustrations

Illustrations drawn by an army of popular creators! Have your fill of these captivating pieces!

web site Nekoyashiki http://www.ne.jp/asahi/hp/belfacs
Illustrator involved in game character design, among other things. Representative works include "Memories Off", "Twin Love", and "Chaos; Head", with the most recent work being "L@ve Once".

Sasaki Mutsumi

CREATOR No.013

Arisaka Ako

website Stem.04 http://gips.velvet.jp/

Each of the Vocaloids has their own distinct personality, which makes them very attractive. I don't usually get the chance to draw Rin and Len, so this was a nice change.

1. Hatsune Miku original song "Paradigm Shift"
2. "What Are You Looking At?" Posted on website.
3. Hatsune Miku original song "Cosmonaut"
4. Hatsune Miku original song "Electric Love"
5. Doujin CD jacket "Stellarium"
 Right page: Previously unpublished

029 VOCALOID CREATORS' ILLUSTRATION GALLERY Part 1

CREATOR No.012

Ui

Rin is too cute, it almost hurts... The Kagamines are so tasty.

web site DOMINANT http://satsu068.zouri.jp/

1. Zenryoku-P/Orebanana-P video submission illustration
2. Lelele-P doujin CD "All Night Le Le Le!"
3. Negidaku-P concept illustration
4. Buriru-san doujin CD "Nimaime Nau!" ("Handsome Guy Now!")
 Right page: Previously unpublished

CREATOR No.011

Ichiyo Moka

website Chocolate Latte http://latte.candypop.jp/

I love the Vocaloids and how their image changes depending on the song. I want to keep drawing them with all kinds of different faces.

1. Posted on website; Megurine Luka birthday illustration
2. Commercial CD "Kimi no Iru Keshiki" ("Scenes with You") booklet illustration
3. Commercial CD "Kimi no Iru Keshiki" ("Scenes with You") jacket
4. "Akahitoba" ("One Red Leaf") video illustration
Right page: Previously unpublished

CREATOR No. 010

Linco

website http://lineco.jp/

No matter how deformed you make them, no matter what clothes you put them in, no matter what expression you put on their faces, you can always tell who is who. This flexibility really stimulates my imagination, and I'm still drawing them today. The Vocaloids are so attractive; not just with their singing, but also their visual aspects too.

1. Doujinshi "Ri. Collection 1" cover
2. Posted on website; Doujinshi "Ri." cover
3. Used for the video "Su-Su-Su-Su-Suki, Daisuki: Ozei de Kaite Utattemita [2009 Christmas]"
 ("I-I-I-I-I Like You, I Really Like You: So Many People Drawing and Singing")
4. Doujinshi "Ri. 3" cover
5. Posted on website.
6. Doujinshi "Ri. 4" cover
 Right page: Previously unpublished

CREATOR No. 009

Ryouno

web site petata http://ryonon.web.fc2.com/

I like Vocaloids and masking tape. I also draw illustrations and make videos. ('ω')

1. "Hatsune Miku and Techno Design Show" exhibition piece
2. "The Voc@loid M@ster 14" circle cut
3. Printed in Quarterly Pixiv Vol. 2
4. Deco*27 debut album "Soaisei Riron" ("Mutual Loveability Theory") special insert
5. Doujin group video collection "Panee"
 Right page: Previously unpublished

CREATOR No.008

Shiro

web site longlongtime.org http://longlongtime.org/

So we're finally able to sing with software. Our days are now filled with the deep emotion of the Delay Lama. As for Miku drawings, I often do the jacket illustrations for a group called "P∴Rhythmatiq". Please check them out if you get the chance.

1. P∴Rhythmatiq single act: 01
2. P∴Rhythmatiq single act: 04
3. P∴Rhythmatiq single act: 03
4. P∴Rhythmatiq single act: 06
Right page: Previously unpublished

019 VOCALOID CREATORS' ILLUSTRATION GALLERY Part 1

CREATOR No. 007

Nagimiso

website Nagimiso http://nagimiso.blog.shinobi.jp/

She's all grown up! I draw them tall and thin for my corner of the Vocaloid world.

1 "Hanayurikago" ("Flower Cradle") public illustration for video site
2 "VN02" figure design image
3 "Retimer" doujin CD jacket
Right page: Previously unpublished

017 VOCALOID CREATORS' ILLUSTRATION GALLERY Part 1

CREATOR No. 006

Shinryo Rei

web site Toughness http://shinryo.zashiki.com/

I jammed in all the things I wanted to draw, like twisting cords and synths. Miku's a bit tangled up, and her thighs are really prominent, although that wasn't my intention. The Vocaloids are so full of fun in every way, I can hardly stand it!

1 "10 no Yakusoku/sm2797346" ("Ten Promises") fan illustration
2 "Denshi Gakki Musume Neiro Zukan 1" ("Electronic Instrument Girl Tone Illustrated Encyclopedia 1") LPC + STRAT
3 Happy Birthday!
4 HMO Miku
5 "It's a Small Music" cover
Right page: Previously unpublished

015 VOCALOID CREATORS' ILLUSTRATION GALLERY Part 1

CREATOR No. 005

Kuu

website Black Cat Canned Goods http://Kandsume.blog.130.fc2.com

I had the idea of just drawing my own Miku, and since I was free to draw what I wanted, this was really a lot of fun. :)

1. Nico Nico Douga "Robot Band: Miku maku! @Miku-san, Rin-san, Le(ry"
2. Nico Nico Douga "Miku Miku Check"
3. Nico Nico Douga "Lovely Vocaloid 2010 Love Extended"
4. Website illustration
5. Doujin CD "Video Game Mikutorica Vol. 01"
 Right page: Previously unpublished

013 VOCALOID CREATORS' ILLUSTRATION GALLERY Part 1

CREATOR No. 004

akka

web site The overlay mixer is invalid. http://pixiv.cc/akka_1172/

For this book, I decided to draw Vocaloid characters I don't usually draw.

1. Previously unpublished
2. Previously unpublished
3. Previously unpublished
Right page: Previously unpublished

VOCALOID CREATORS' ILLUSTRATION GALLERY Part 1

Vocaloids

CREATOR No.003

meola

web site carbon http://meola.ame-zaiku.com/

Young people and trends and music and culture and art... it's like a dream.

1. Doujin CD "Solitude Freak" jacket
2. Doujin CD "Rebellion on the Sunday" jacket
3. Doujin CD "Try!" jacket
4. "The Flower that is You", illustration posted on Pixiv
5. Doujin CD "For a Sick Boy" jacket
Right page: Previously unpublished

009 VOCALOID CREATORS' ILLUSTRATION GALLERY Part 1

CREATOR No. 002

TNSK

web site TNSK Gallery http://chromaofwall.com/

I'm honored to have been invited to be part of such a wonderful book. The Vocaloids have already become essential work music for me; I'm basically an addict. I'm looking forward to even more wonderful songs, pictures, and videos from now on too.

1 First appeared in Melon Tea P's video "Moratorium Drive"
2 First appeared on Pixiv
3 First appeared in a doujinshi
4 First appeared on Pixiv
5 First appeared on Pixiv
Right page: Previously unpublished

007 VOCALOID CREATORS' ILLUSTRATION GALLERY Part 1

CREATOR No.001

KEI

Hello, I'm Kei. I decided to make Miku fly... or rather float, maybe. She should definitely be able to fly too, though. No, no, I don't know. Maybe she can't? No! Maybe, just maybe...?

website KEI Gallery http://kei-garou.net/

1 Arcadia August 2010
2 "Comic Rush December 2010
Unofficial Hatsune Mix title page (Jive Ltd.)"
Right page: Previously unpublished

005 VOCALOID CREATORS' ILLUSTRATION GALLERY Part 1

VOCALOID CREATORS' ILLUSTRATION GALLERY PART 1

Vocaloid Creators' Illustration Gallery Part 1

A gorgeous collection of previously unpublished illustrations and representative works created by Vocaloid artists!

CONTENTS

003	**Vocaloid Creators' Illustration Gallery Part 1**
030	Sasaki Mutsumi
031	Komei Keito
032	Suzuri
033	Ekusa Takahito
034	Kamijo Eri
035	Nanzaki Iku
036	Homare
037	**Vocaloid Creators' Illustration Gallery Part 2**
075	**Vocaloid Extras**
076	Hatsune Miku: Project Diva
086	"Hachune Miku's Daily Adventures" by Ontama
088	Hatsune Miku Collaborations
090	Jacket Visual Chronicle

comic

097	"Revolve" by Sayaka Gojoh
109	"For Someone" by Wasabi
119	"Time Capsule" by Ponjiri
127	Creators Index

初音ミク
Graphics 2
VOCALOID ART & COMIC